Leisure Arts 13

Basic
Oil Brushwork

Clifford Bayly

SEARCH PRESS

Wellwood North Farm Road Tunbridge Wells

Introduction

Man has always enjoyed making marks. Most of us are familiar with prehistoric rock and cave paintings but even before then man was chipping marks and signs into stone and scratching lines into bones. This process of sign making was very extensive: far more than present evidence suggests for the majority of work of primitive man has been lost to us as it was made on perishable material, to say nothing of his drawings in the sand and scratching on surfaces which eroded rapidly away.

We have not changed essentially in our fascination with making pictures. Naturally our tools have become more sophisticated, but they are basically the same as those used by artists and craftsmen several centuries ago, although modern technology and the development of plastics have given us the nylon polyester brush and acrylic paint. The process of picture making is, in the main, traditionally similar, and provides tremendous enjoyment and satisfaction for all of us who are prepared to spend some time practising and studying the subject.

There are three principal aspects to basic oil brushwork: the various techniques and methods of applying paint to canvas and board; the actual tools of the trade; and the attitudes and approaches necessary to appreciate the choice of techniques available. This book aims essentially to be practical and it should be followed up by experimenting in practical working conditions.

Bear in mind that, however brilliant the artist becomes in the techniques of applying 'paint to canvas', these should not become an end in themselves. Sheer virtuosity can never replace content; it only constitutes the means by which to express your approach to the subject of your painting.

In the early stages do not invest in a large number of tools and materials. A modest range of basic items will suffice to start with; and this can be supplemented as your skill develops. It is a false economy to buy cheap tools.

However, when practising techniques it is not always necessary to use expensive paints and canvas. A list of necessary tools and materials is included at the end, on page 30. A good artists' supplier's showroom is to me an Aladdin's cave. I have never lost the enthusiasm and excitement I felt as a child when looking at boxes of paints and other 'goodies' in the local art shop. The sheer variety and visual quality of most of the items is endless: brushes of every shape and size, little pans of watercolour paint, large squashy seductive tubes of oil colour, bottles of various oils and varnishes from clear to dark brown, and smooth wooden or pristine white palettes. Appreciation of the basic qualities of materials in their own right is an essential part of any artist's attitude to his or her work.

The artist and the child have much in common. Maturity comes from making marks that are not only pleasing to oneself but communicate information and aesthetic pleasure to others.

In the demonstrations in this book I have confined myself to illustrating techniques rather than producing finished paintings; to show methods rather than an end-product.

Brushes

The brush is the basic tool of the painter. It is essential from the start to work with good quality brushes. Cheap badly-made ones will only give poor results and dissatisfaction. Good brushes are a pleasure to work with and will last far longer.

Take a well-made brush and just look at it. Finely shaped handle, clean bright ferrule and silky springy bristles. Hold it, feel the 'balance', check the soft resilient bristles. Doesn't it make you impatient to get painting? A well-made brush is a beautiful object in its own right.

Brushwork is not produced by the brush but by the painter using the brush. This may seem obvious yet it underlines the fact that any tool is only an extension of our hand and thoughts. Its marks will reflect our approach to our work. Brush strokes also demonstrate the character of the painter. Short nervous jabs, long langorous sweeps, dynamic swirling rhythms all describe different reactions and approaches to a subject.

Overleaf I have prepared a short practical description of most of the brushes normally required for most paintings. The illustrations are intended as an identification parade for reference throughout the book.

Although the wide choice of shape, size, quality and price of brushes can be daunting, do not despair. Their various functions will become evident as you progress through the book and you will find it comparatively simple to decide eventually which ones you need. Start, though, with a modest range of sizes, say 2, 3, 5, 7 and 10 in flat or filbert hog-hair bristle, a size 8 flat sable and sable rigger size 3.

A fan brush is not necessary to begin with but useful when you have developed more confidence.

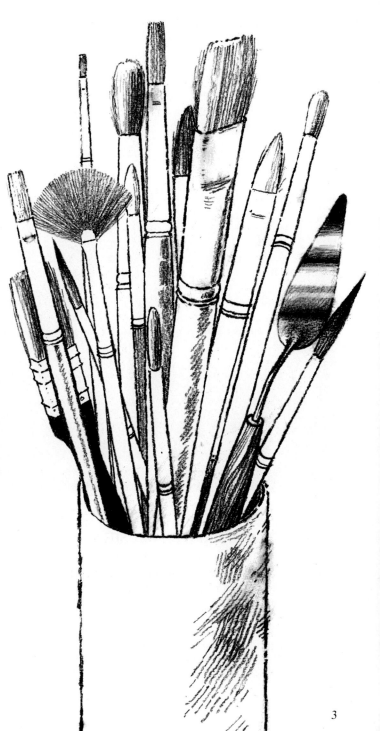

3

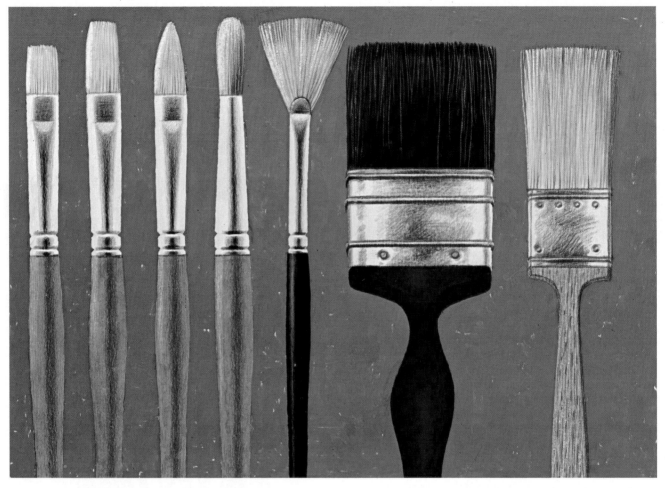

Left to right: Short bristle, long bristle, filbert, round, fan, house-painting style brush, varnishing brush.

HOG-HAIR AND BRISTLE BRUSHES

Bristles should be set in the brush so that the natural taper is with the finer end towards the tip and the natural bend curved in toward the centre of the brush. This prevents splaying. Shorter bristles are for use with thick paint.

Filberts are flat in section; the pointed end is useful when drawing in or working on smaller forms.

The fan brush is for blending colour after it has been applied with normal brushes: sky, foliage, and for hair in portraiture.

House-painting style brushes are useful for applying primer and grounds to board or canvas. The varnish brush is thinner in section to cover areas smoothly and has long bristles to give a soft and flexible touch.

4

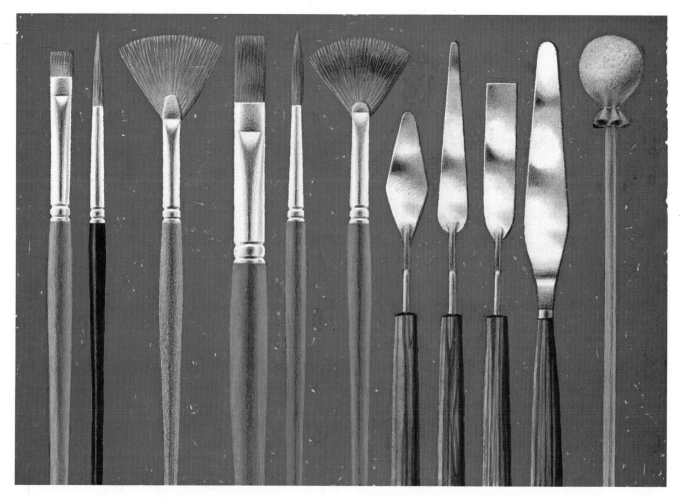

Flat, rigger and fan sable; flat, rigger and fan nylon; painting knives, palette knife, mahl stick.

SABLE, NYLON AND POLYESTER

Long sable brushes are for fine work, round section or riggers for lines, fans for blending. Synthetic fibres are hard-wearing and used mainly for acrylic painting. Polyester fibres are the nearest to bristle and are less expensive, but I would only recommend them for oil painting after one has acquired confidence in the use of bristle brushes.

PALETTE KNIVES AND MAHL STICK

Cranked painting knives supplement our brushwork. Since paint is applied in strokes or flat slabs, they add physical texture to the surface of a painting. Do not use them until you reach a fair degree of competence with brushes.

The palette knife is used for mixing large amounts of paint on the palette to avoid wear on brushes and for scraping off surplus paint. The mahl stick has a padded top which is rested against the side edge of the painting when supporting the working hand.

Grounds and underpainting

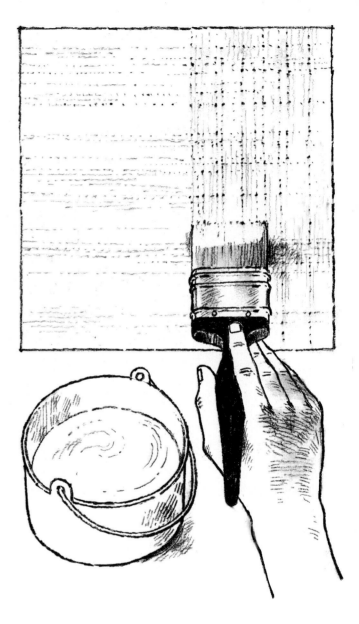

Your board or canvas surface can have a direct effect upon the final appearance of your painting. Most painters prefer a textured surface. With prepared canvas this exists already and is known as the 'tooth' – coarse or fine according to thickness of the thread and the way it is woven. Canvas-textured and smooth boards already prepared can be bought and are cheaper than prepared canvas: preparing your own boards is cheapest of all.

Giving yourself a strong tooth on which to work can help you understand more fully the possibilities that exist in oil painting. Naturally the degree of texture should be related to the size of the painting surface and the subject-matter. A strong texture should not normally be used on small panels or canvases.

I shall confine myself to describing the priming of hardboard panels, as they are the cheapest and most easily obtained supports for oil painting, and do not need a back frame or stretcher.

Cover your surface evenly and thinly with one coat of emulsion/acrylic primer and let this dry thoroughly. Now apply one or more further coats of primer or ground to achieve your required texture. If you want a very smooth final effect in your painting, try to eliminate brushmarks by painting the second coat crosswise against the first, then rub down with fine glasspaper when the paint is dry and hardened.

Materials

The textures illustrated on this page were applied to hardboard, but one can practise them on primed paper or card, satisfactory and economical supports, but which have little permanence.

The ground textures illustrated here are all basic and easy to achieve.

a. This consists of one or more coats laid down with the brush strokes running in one direction. A coarse bristle brush will give strong texture and a softer brush a smoother finish. This fact applies to any texture you may produce.

b. For a canvas-like base apply your second coat of ground and any subsequent coats in the opposite direction to the previous coat leaving each application to dry before beginning the next.

Textures a. and b. both give a static quality to the ultimate effect of the painting.

c. For a painting in which the subject demands a vigorous effect or where movement is an important element it can be helpful to produce a ground texture which has a strong feeling of movement itself. This is achieved by swirling or twisting brush strokes running counter to each other so that the effect is uniform over the panel but still contains movement and excitement.

d. Stronger textures can be produced by tools other than the brush. After a first coat of ground has dried, the second should be applied generously and allowed to dry a little before texturing, for which you use a pointed stick or brush handle.

Care and discretion should be exercised in producing such textures as they can easily become too strong for the subsequent painting; but practise and experiment!

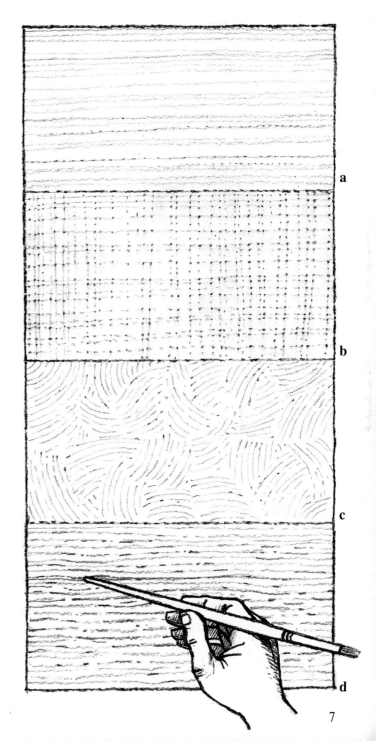

a

b

c

d

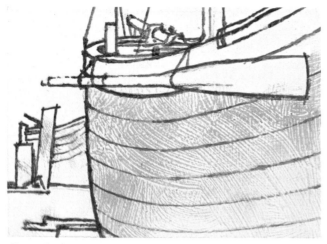

Stage 1

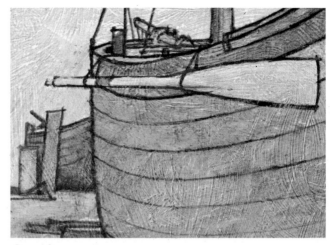

Stage 2

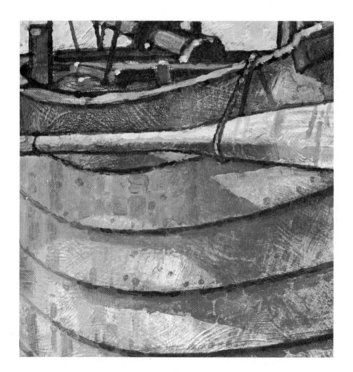

Monochrome detail of the finished painting (opposite) which shows the swirling or twisting effect created by the prepared ground.

Ground textures: demonstration

This painting features the qualities of varnished boards and other wood forms against sky and beach. I therefore chose as the most appropriate ground the one illustrated on page 7 under *c*.

Stage 1

I drew in the main forms using a dark neutral colour, in this case raw umber mixed with a little permanent blue and white. I first tried out the effect of the ground brush texture by rubbing ochre lightly over the surface. This was not quite what I wanted so I then decided to scumble the surface – that is, to paint solidly over the area and then to wipe or scrape away the surface paint, leaving a residue in the hollows of the ground texture. This simple technique allows the original ground brushwork to show to maximum advantage.

Stage 2

Having tried out these two methods of achieving a particular effect I was then able to block in all the main areas of the painting simultaneously producing some-

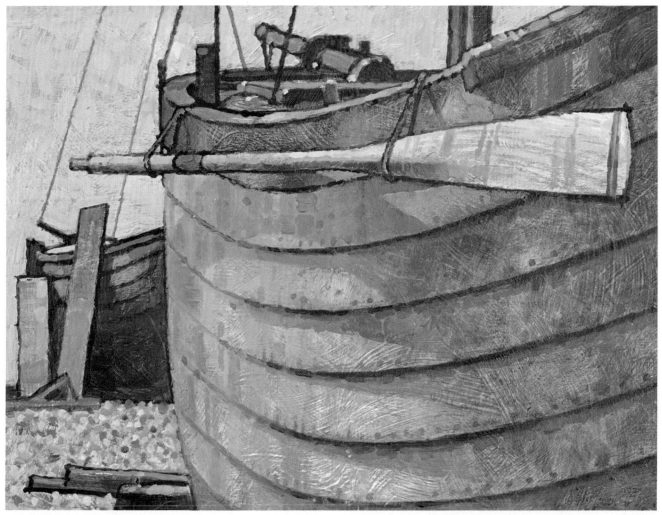

Stage 3 – the finished painting

thing of the quality of the varnished wood of the boat by wiping off surplus paint.

Stage 3 – the finished painting

By further application of stronger colour mixed with turpentine and a little picture varnish to give more transparency, I was able to build up the final effect of the varnished wood. It was then necessary to use normal brushwork on areas such as the sky and the side of the boat where it reflected the cool light of the sky. The beach area was painted with a small flat sable varying the colour and tone of each short stroke to build a texture of pebbles.

In this demonstration it is the ground that has given it its textural quality and shows how you can, by thinking beforehand about the blank surface texture you wish to paint on, enhance the final result.

Brush control

After grounds and underpainting it is logical to consider the problems in producing finished brushwork.

Holding the brush

There is no single correct way of holding a brush other than the way when you apply the paint-loaded bristles to the picture surface and the mark they leave is exactly the one you wish to make! However, the three illustrations on this page give you an idea of the reasons behind the grips shown which are among the most commonly used by practising artists. Remember the brush itself is inert: it is your fingers, hand, wrist and arm up to the shoulder that control it. Any grip that restricts the appropriate mark from being made is obviously wrong: only practice will enable you to hold your brush without apparently being conscious of it so that the result accords with your intention.

a. This way of holding the brush is probably the most natural as it is the way most of us hold a pen or pencil. Although natural, it allows only a limited area of control. Within this area, however, we are able to paint quite fine detail.

b. This is the most widely used method of holding the brush. In fact the hand readily takes up this position when working broadly, particularly on large areas where a reasonable degree of control can be sustained over a wide area.

c. This grip is a compromise. It ensures quite a high degree of control over detail but is not so cramped as in example *a.* and sustains control over a fairly wide area. It enables you to work at a good distance from the surface, keep a light touch to your brush strokes and yet control the tip of the brush almost as well as in example *a.*

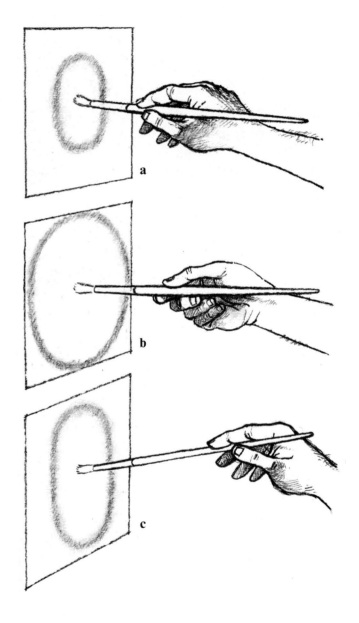

Brush control: demonstration

This demonstration (pages 12–13) shows how the character of the brush stroke helps to influence the total effect of the painting.

As this subject is essentially cool in colour – blues, greys and greens – I decided to use a complementary or opposite-coloured ground, perhaps a rather odd thing to do, but by keeping my brush strokes slightly separated from each other and letting the warmth of the ground colour glint through here and there a scintillating effect is obtained which will vitalise the finished painting in a simple yet subtle way.

Palette knife

Its name suggests one of its functions, which is to mix paint in quantity on the palette by working colours together using a circular spreading movement. It is not advisable to use a brush for this as it twists the bristles and results in rapid wear.

Using the palette knife on the painting surface, by scraping carefully in broad strokes, will remove most of the paint already applied, yet leave sufficient to retain the image. The resulting surface is pleasant to work into and many artists use this technique effectively.

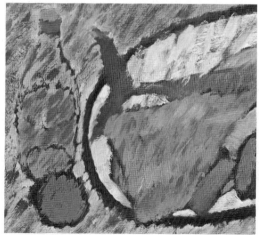

Monochrome detail of the second stage demonstration of the painting where the artist blocks in his principal colours over the opposite coloured ground.

Stage 1

Stage 2

Stage 3

Stage 1

I covered the ground with a strong warm red; cadmium red hue and yellow ochre thinned considerably with turpentine. When dry I indicated the main forms simply with raw umber, allowing my lines to become quite thick.

Stage 2

When blocking in I applied brush strokes lightly in colour thinned with turpentine, in order to cover the whole of the painting as quickly as possible with something of the final colour qualities. This is preferable to completing bits here and there while still leaving areas of the uncompromising red ground which would make it difficult to retain unity in the picture. I kept the brush strokes well separated from each other and short when beginning to cover the original drawing lines.

Stage 3

Having established a unified image, I now build up my colour more accurately, still keeping my brush strokes simple, short and separate. These enable the ground colour to glint through and prevent the paint from building up and becoming slimy. Remember to keep

an eye on the tone values while mixing colour – tone being the degree to which a colour is dark or light.

Stage 4 – the finished painting

There can now be more attention to detail, the painting of which must not be smaller in scale than the size of the average brush mark already used. If this were to happen the detail would appear not to belong to the painting and by comparison the previous brush marks would appear crude and heavy.

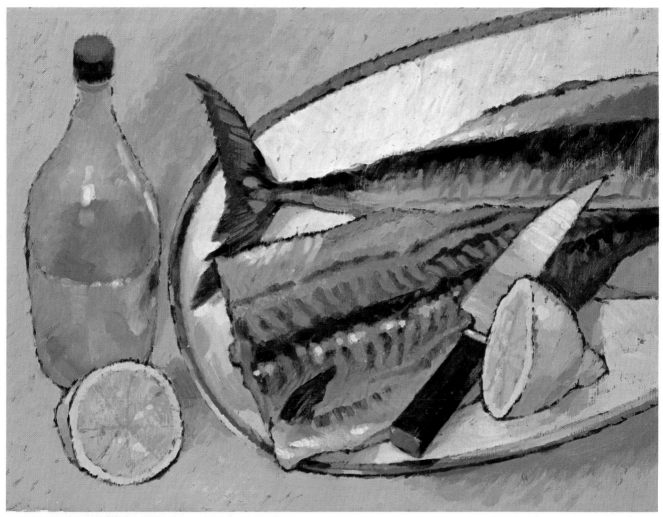

Stage 4 – the finished painting

I make final adjustments to tone and colour while again taking care not to fill in between brush marks and at the edges of forms where little flashes of ground colour are permitted to glow through; for these give crispness and sparkle to the painting.

When using open loose brushwork like this, it is advisable to keep a certain grain or general direction to these strokes. As I am right-handed the natural direction for this grain runs diagonally from top right to bottom left or upwards along the same axis.

Medium and techniques

Different painting materials strongly affect our brush-work and consequently the general appearance of a painting.

First, the consistency of the paint, which is the painting medium itself. For clarity I am confining myself here to linseed oil, turpentine and varnish.

Paint consistency directly influences our brushwork. When, for example, blocking or scrubbing in large areas at the start of a painting it is best to thin down the paint with turpentine and to use a round section hog-hair brush of good size.

When painting forms requiring simple flat areas of paint, it is advisable to use somewhat thicker paint by mixing with it only a little turpentine and adding a small amount of linseed oil. Use a flat hog-hair bristle brush and lay the paint on with short clean strokes. Do not smear it or stir it about. Freshness of colour and depth of tone are always impaired if the paint is disturbed too much after it has been laid down.

In areas of a painting in which it is necessary to reduce the effect of brush strokes – such as clear skies, soft surfaces, hair and fur – it is helpful to keep the paint wet for a longer period than normal. This is achieved by mixing the paint with linseed oil only and then blending the brush strokes together with a clean soft sable brush or a fan brush specially made for this purpose.

To render texture, try dragging the brush across the surface of the board or canvas to give a fine broken effect. This requires a dry sticky paint consistency; it is best to use paint or mixtures straight from the tubes without adding turpentine or oil medium.

Medium and technique: demonstration

The technique just described referred only to the effect of painting consistency on brushwork. This demonstration is a 'sampler' which shows some of the effects of materials on brushwork. Normally one would not use such a variety of techniques in one painting as it is difficult to retain unity and consistency. The demonstration should not, therefore, be looked at as a single painting but as samples put together for convenience.

Detail 1 (page 16)

Here we have three simple techniques in which the amount and type of medium plays a part.

The foliage is painted with short brush strokes, laid on in the direction of the growth of the tree, using a small round sable brush and paint given a creamy consistency by adding oil and turpentine in equal quantities.

The sunlit wall surface of the house is achieved by using thick paint applied with a painting knife which is then left until quite dry (several days in this case), and brushed over with a creamy brown oil colour thinned with turpentine and then wiped clear of the higher surface leaving a residue in the hollows to emphasise the texture – scumbling. The other wall in cool shadow is painted normally, with a small flat sable brush.

The stone jetty is painted similarly with a slightly thicker paint consistency which enables me to drag the brush here and there to produce a fine broken texture.

Detail 2

This is an example of fairly coarse brushwork where some blending and softening has been used to give a smooth gradation from one colour into another to produce a breezy animated effect. I used a flat hog-hair bristle No. 4 and produced the blending using a similar clean bristle brush lightly drawn across the paint surface. The paint was mixed with turpentine and oil.

Detail 3

Another example of scumbling – using the painting knife for the rocks and the boat.

The process of building up the underlying layer of paint is known as *impasto*. The soft reflections are a combination of slightly softened brush strokes and dry colour dragged across once the lower layers have dried.

Detail 4

An example of impasto where a wood-like texture has been achieved by scoring the original under-layer with a brush handle tip before scumbling with a dark brown. This texture is emphasised by the smoother painting of the sea in the background, which was achieved with paint mixed with oil and turpentine and a round long-haired bristle brush, No. 2.

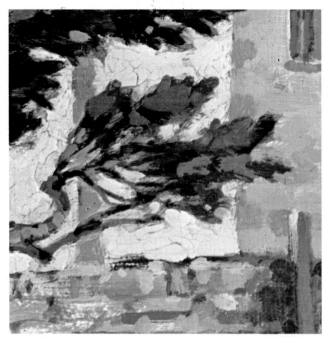

Detail 1

Detail 2

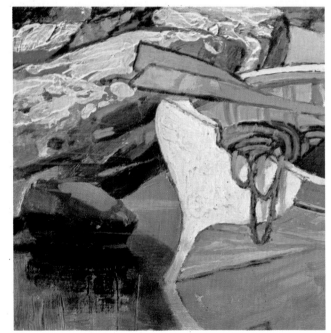

Detail 3

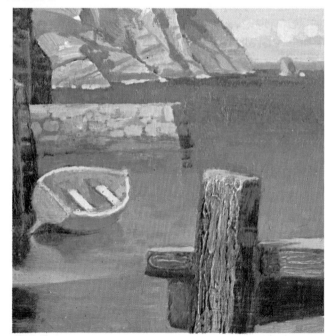

Detail 4

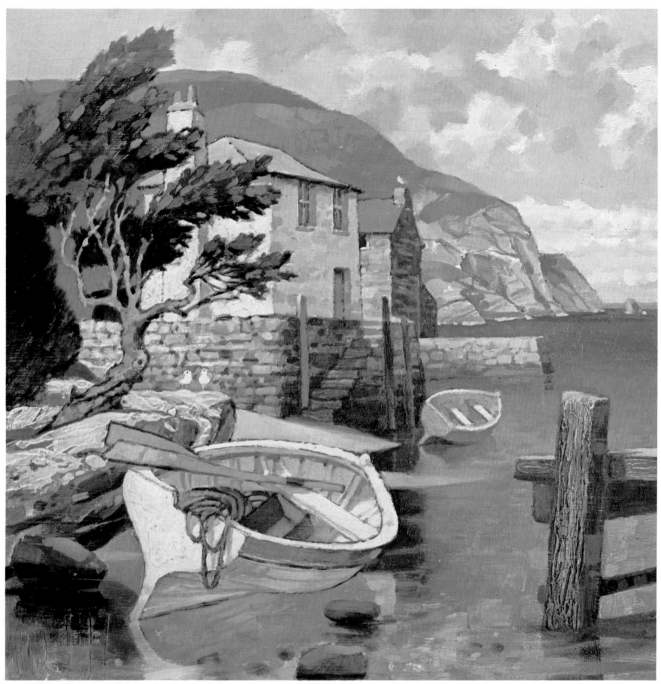

Detail 5 – the complete painting

Dynamic brushwork

Here we consider brushwork which is largely directional. The brush strokes follow the contours of the forms or run over them in such a way as to assist the drawing by adding solidity and structure.

When choosing to practise this form of brushwork consider it carefully in relation to the subject-matter and the composition of the painting. It emphasises movement and rhythm and is particularly suitable for paintings in which there are strong directional lines as with rolling downland, trees blowing in the wind, fire, clouds, animals and figures in movement.

When painting with this technique great care should be taken to keep the paint fresh by not churning it up on the surface of the painting as you work.

It is advisable to mix colour carefully on the palette and then place it on your work very positively – that is, lay the stroke on and leave it. Do not mix and blend on the picture surface or you will find that the paint becomes muddy and dull.

You can use short strokes, dabs or long strokes but remember that the brushwork must remain secondary to the purpose of the painting – not attracting too much attention to itself at the expense of the subject-matter.

It is worth practising this technique on a very simple subject such as a plant in a pot or a small growing shrub, where strong lines of growth are rather pronounced.

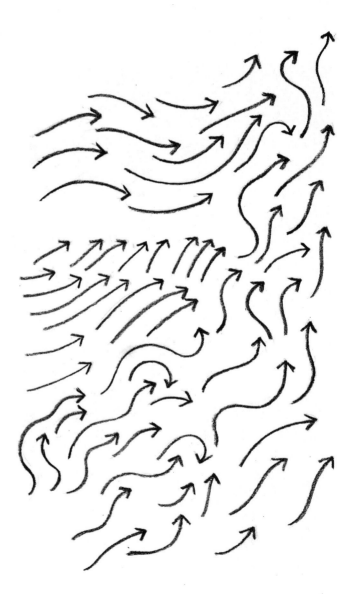

Dynamic Brushwork: demonstration paintings

To illustrate this approach to painting I have produced a simple diagram showing the direction of the brush strokes of the painting on page 20 in which smoke and flames play a prominent part.

The stronger the brushwork the thicker the paint; consequently one must expect to use far more paint and medium in this technique. It is possible to underpaint with thick acrylic/emulsion, building up strong strokes and textural effects, and then work over this with oil paint later when dry, but it is best to practise these brush strokes directly.

In both the demonstration paintings on pages 20 and 21 I have purposely left them incomplete. By this means I show more clearly the way in which the brush strokes also help to draw the subject-matter.

I have emphasised the contours of some of the pictorial elements, possibly over-simplifying them, but this type of brushwork tends slightly to formalise objects, and to dramatise the subject-matter. This is so in the painting of the sky and fields with their swirling lines of burnt straw.

In painting the smoke, I carefully observed the forms which occur and decided to use long swirling strokes of the brush to show these to advantage. For this type of stroke I chose a round hog-hair brush and, using the paint thickly and generously, worked several tones together, being careful not to overwork the mixing on the surface of the painting. In fact I waited for my first strokes to dry and then went back over them adding extra emphasis to the lighter areas. By this means I was able to avoid the muddiness referred to earlier. An interesting visual effect possibly worth noting here is the cold blueish colour that smoke assumes when seen against the darker landscape. This however turns to a warm brownish hue when the smoke is seen silhouetted against a light surface such as the sky.

In the other painting (on page 21) I have picked more definite subjects, less atmospheric than smoke and fire.

The swirling water gives another example of long animated brush strokes. The tree is somewhat different, and although the shape is rather sinuous the brush strokes need to suggest the texture of bark and therefore I have kept them short but have still followed the rhythm of the growth lines. This is also the case with the grass in the foreground, as it is drawn by the brush strokes themselves.

I have overemphasised the quality of unity by keeping to very similar colours throughout, because I wished to draw attention mainly to the form and direction of the brushwork.

The simplification of shapes is also evident, and contours are emphasised by the painted outline – in some cases left from the original drawing-in guidelines.

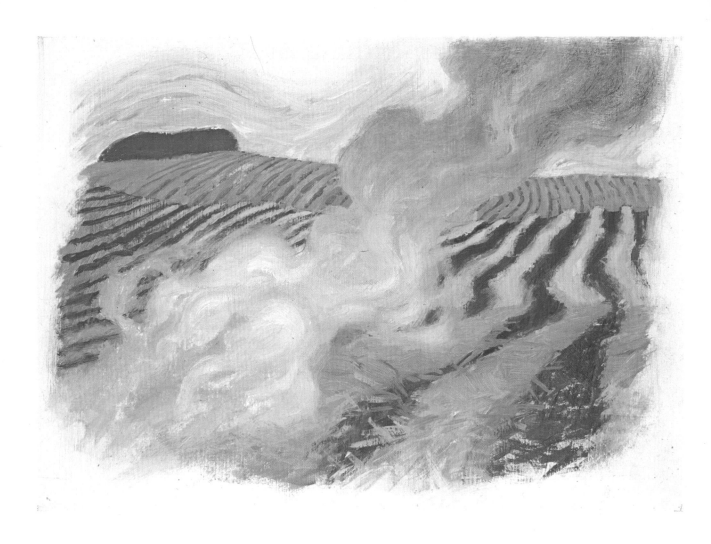

In this simple example the directions of the brush strokes have a similar quality to the lines in the landscape. This assists in keeping the picture unified and relates the brushwork to the subject-matter. The distant field has been kept simple and would need considerable attention if this painting were to be completed.

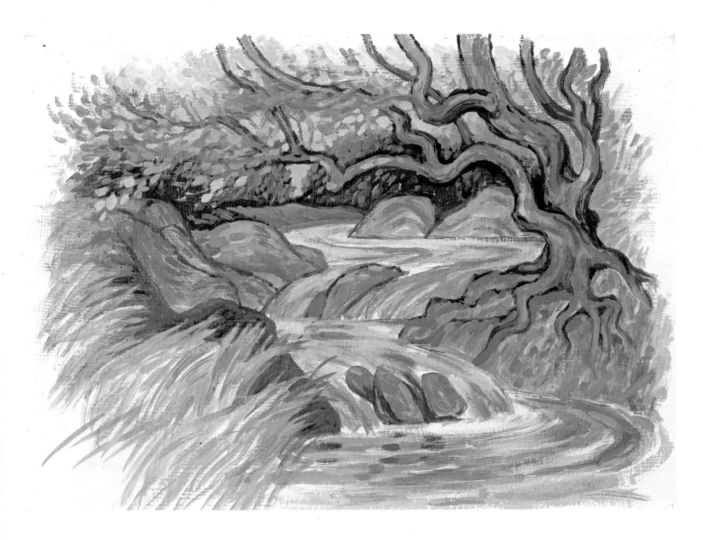

There is an affinity between all the elements in this painting. The pattern of growth and strong directional lines in the water combine to give a sense of rhythm and movement which is characteristic of this style of work. To complete this painting it would be necessary to work into the smaller forms and redefine several elements which are a little too basic in this demonstration.

Surface qualities

The surface of any painting owes its character to a combination of three main factors; ground/base, brush-work and the consistency and quality of paint.

The relationship between these factors can be understood most easily by practising painting on to various textured grounds with different brush types and sizes and with varying consistencies of paint. If you were to keep a systematic record of each of these exercises you could see in advance something of the surface quality attainable with your own equipment and materials.

Although some of the previous sections and visual examples in this book have referred to this subject I shall emphasise the main methods of controlling surface qualities in greater detail.

First, consistency must be the key to the use of these techniques. Do not employ a wide range of them in one painting.

Since the ground quality and texture really do affect the final appearance of the painting, try to make use of this fact as much as possible.

There are several techniques which emphasise the ground texture; painting and then scraping with a palette knife is one. This leaves sufficient paint in the cavities of the ground texture to hold the image and it can be worked into later. If this later work is kept to a minimum a very pleasing surface effect is achieved in which the original ground texture plays a large part.

Another technique which can emphasise the ground texture is glazing. Glazes are mixtures of linseed oil, a little picture varnish and very little turpentine stained with whatever colour you require. Applied over the ground base they can be scrubbed in loosely for a vigorous-looking brushed effect or painted on smoothly for deep shadowy areas. To emphasise the ground texture even more, glazes can be wiped lightly with a soft cloth pad which again leaves the paint in the hollows of the texture and clears the surface of most of the colour. Naturally the stronger the texture beneath the glaze, the greater the effect of this method.

Glazes add a quality of depth to the painting surface but must be handled carefully as they can, if used indiscriminately, give a hard glassy effect.

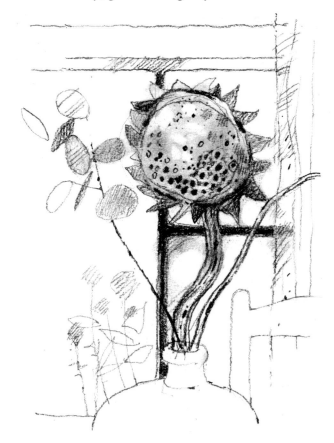

Surface qualities: demonstration

Light plays an important part in many paintings and a basic understanding of its qualities can help to produce works which contain an inner glow and extra dimension. In this demonstration I have chosen a still life as a useful way of showing how light can be represented and held within the painting.

In this instance the technique employed is a simple combination of two methods of applying paint. This is to use solid pigment in the light areas; and in some cases to build up the underneath ground texture with white, which is allowed to dry, progressing through to the darkest shadow sections, gradually reducing the solid colour until these dark areas are painted entirely by the use of glazes. Thus the light areas appear to advance out of the darker shadowy sections which, by contrast, appear to recede.

Detail 1 (page 24)

I apply two glazes, both of cadmium red deep and a little raw umber. I wait for the first to dry and then wipe out the area of illuminated wall with a rag and paint the curtain loosely with thicker colour into the wet top layer of glaze. This is a part of the painting where there are good examples of all paint surfaces – solid light sections, intermediate passages where we find the brightest and richest colour, and dark areas of glaze.

Detail 2 (*see also sketch opposite*)

The dried sunflower is underpainted in white and, when dry, glazed with transparent golden ochre and cadmium orange with a little raw umber rubbed into the central texture (which is formed by indenting the original white in parts when wet with the handle of a small paint brush). The same technique is used for the stalk.

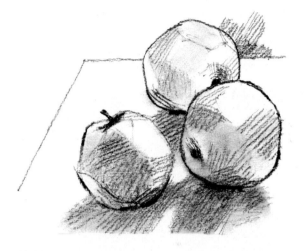

Detail 3

The painting of these apples shows how solidity can be obtained by using a good thick paint on the well-lit faces of the fruit, leaving the partially glazed areas to look after themselves, and then just tipping in a small dab or two of reflected warm light in the shadow side to complete the illusion of rotundity. This is also helped by the transparent cast shadow of the apples thrown on to the table. This is the original colour of the table top. Lighter, more solid colour is applied towards the window to give it substance.

Detail 4

Various textures using underpainting, fading round through shadow on the jar into reflected light, help the illusion of solidity. Also in this section is the darkest area of the painting, the cat curled up on the chair. This is produced by two glazes, first of raw umber and then one of permanent blue with a touch of black.

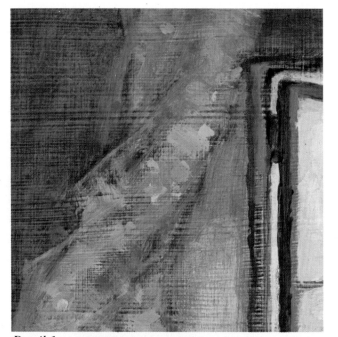

Detail 1

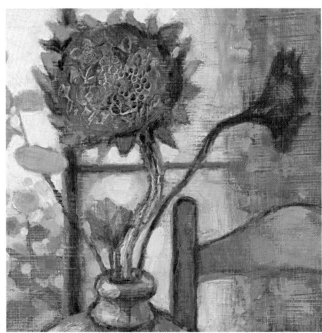

Detail 2

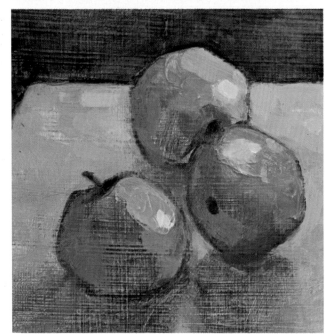

Detail 3

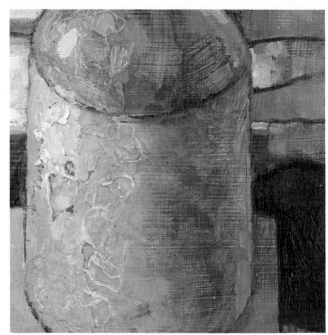

Detail 4

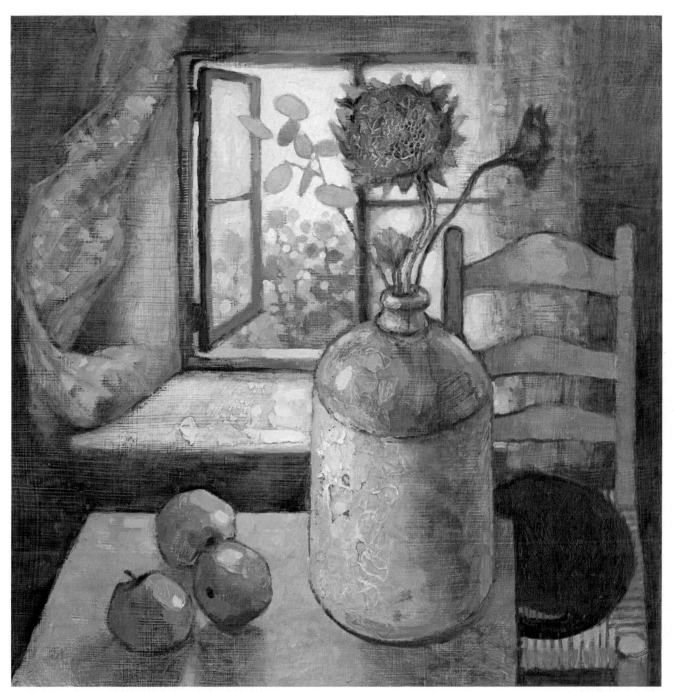

Detail 5 – the complete painting

Mood and atmosphere

Although these are usually suggested through using such elements as colour, form and light, sympathetic brushwork is essential. Scale is most important as the brush strokes could obtrude if they are too large, or appear fussy and laboured if too small.

A key to scale is often given by the subject itself. For instance, you are proposing to paint a group of trees in which the pattern of fine branches and leaves is what interests you. Rather than paint in each branch you might try instead painting the spaces of sky between the branches having first drawn them in rather more heavily than you might normally. The shape of the branches left by this method becomes far more varied and interesting and the problem of the scale of your brush strokes is solved as all your brushwork over the rest of the painting can be to the same scale.

For the above scale of working and for a painting of about 60 cm x 40 cm (24 in x 16 in) it would be well to use hog-hair brushes of around sizes 5 to 7, flat or round according to the elements in the work. For a very strong coarse effect one could use size 8.

Naturally for blocking-in early in a painting, a larger brush is most useful but, as the work progresses, use smaller brushes. For a very fine finish to a painting in which mood and atmosphere play a strong part, be careful not to use too small a brush. For the sizes quoted above size 3 is the smallest that can usefully be employed.

In the following pages these general hints are practically demonstrated.

The previous sections of this book will by now have covered most of the basic problems and possible techniques in brushwork. It is therefore now a matter of appreciating the need for careful judgement and selectivity in deciding on the approach best suited to your subject-matter.

In some landscapes the mood is first set by the use of evocative colour – say, cool blues and greys if distance is to be a major element in the painting, or yellow and brown if the subject is an interior lit by artificial light.

After the colour mood has been chosen, decide on the type of brushwork you wish to employ. Brush size and the form of the strokes need to be pre-determined so that the blocking-in of the large forms or areas can be carried out in the same character as the later work, even if done with larger brushes at this early stage.

As the work progresses and the brush strokes become smaller in scale make sure they keep the same character to retain the necessary unity throughout the painting.

The character of brushwork, its grain or direction of stroke, scale and form have an important influence on the painting so that the colour scheme and the methods of applying it combine to produce the appropriate mood and atmosphere.

Mood and atmosphere: demonstration paintings

I prepared these two paintings so that the mood and atmospheric qualities of the one on page 28 are contrasted with the flat two-dimensional character of the other on page 29. In this way I hope to show that brushwork in relation to subject-matter has a strong influence on the mood and that it can suggest things without actually defining them.

In the painting of the chapel on page 28 I decided that the predominant colour should be blue to help create a mood of cool freshness which I associate with this subject. I also wished to give the painting a suggestion of rain without actually painting falling water drops in any way. This meant choosing a form of brushwork which, by its scale, direction and the way it was applied would give this quality.

I chose to employ fairly large brush strokes in relation to the size of the painting and to give these strokes a sloping grain over the whole surface of the work irrespective of the forms I was depicting. The method of applying the paint was to lay it on loosely with flat hog-hair brushes; in some places using the thin edge of the brush with a zig-zag writing-like movement over a simple drawn outline.

I started by brushing over the whole surface a strong, slightly transparent blue as a base, using a similar directional stroke when applying the colour.

I left a considerable amount of this ground colour showing between the strokes, and also allowed the original drawing to show here and there.

This painting is left unfinished in order to demonstrate the brushwork. Normally I would work into the distant areas, particularly in the sky and hills, to soften them and take them back. This would mean using a smaller brush, keeping the strokes similar and softening the outlines a little.

The painting on page 29, which is not atmospheric in any way, calls for a different treatment. Here the emphasis is entirely on the two-dimensional pattern of differing textures and surfaces. I varied my brushwork considerably to demonstrate the changes of texture needed to portray the differing materials. Having brushed in lightly the main areas over the drawn shapes using raw umber slightly thinned, I decided to leave this texture on the section below the window as it suggested the rough sawn quality of creosoted boards.

In some areas I left the colour fairly thin so that the texture of the ground could show through, but to bring out the flat quality of the large pieces of panelling I applied shortish straight brush strokes, slightly varying the colour and tone and leaving space between to allow the other texture of the underpainting to show through. This represented the surface of old plywood on which cement had been mixed. On the right of the window I have dragged the colour drily over the surface to help this illusion.

A little cast shadow here and there suggests the light and relieves the flatness just sufficiently to show the form of the materials, and the window gives a little more depth and a point of interest for the eye.

Although there are several different forms of brushwork within the one painting it is held together and given unity by the simple strong shapes.

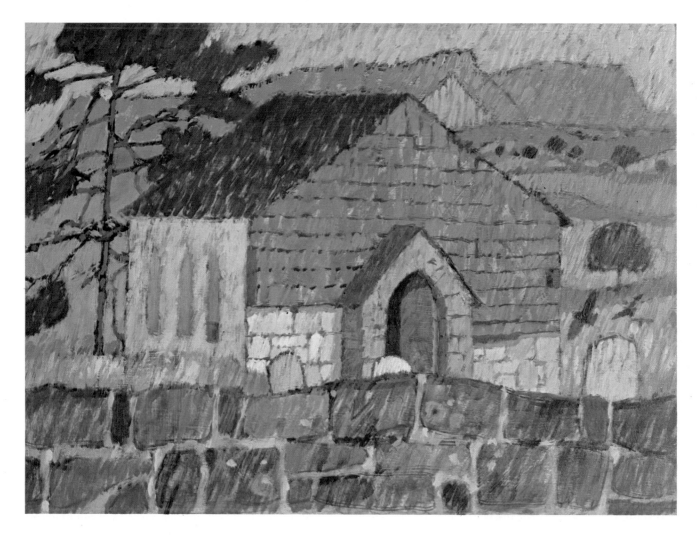

Welsh Chapel

*The blue ground over which I painted gave me the
basis to create the atmosphere of a cool rainy day.
Even when I was painting in the warmer colours the
ground shows through, and adds to the rainy effect I
wished to achieve. This again is emphasised by the
open, short diagonally hatched brush strokes I
employed throughout the subject.*

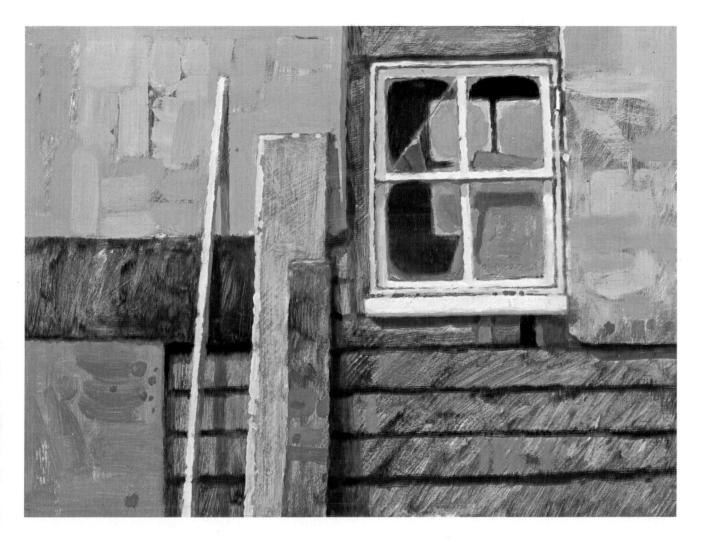

The Broken Window

Although just a demonstration and not a completed picture, this shows how, compositionally, quite simple rectangular and square forms, relieved with a few diagonals, plus the use of tone and colour, can make a satisfying exercise. Each shape has its own complementary brushwork describing the various textures in the subject.

Do's and Don'ts: a brief summary

'Do's'

Do choose your basic tools sensibly. Spend sufficient money on purchasing them and look after them carefully.

Do consider your ground as an important factor in determining the final effect of your painting.

Do hold your brushes so that you can maintain maximum control without your wrist and arm becoming rigid and stiff.

Do relate the character of your brushwork to the subject-matter.

Do mix your paint on the palette rather than on the painting.

Do apply your brush strokes to the surface positively and cleanly.

Do mix your paint to the right consistency for the brush strokes you are using. Practice and experience will dictate the amounts.

Do maintain a unity in your painting by keeping the character of your brushwork consistent.

'Don'ts'

Don't over-texture the ground. Relate the scale of the texture to the size of your painting.

Don't let the scale of your brushwork become more noticeable than the subject matter of the painting.

Don't use several different systems of brushwork in one painting.

Don't allow the paint to build up too much on the painting. Scrape the surplus away with a palette knife if necessary and repaint.

Don't scrub the paint on to the surface with flat brushes

when starting. These are made for a stroking or dabbing movement. Round section brushes are better for any large scale basic blocking-in during the early stages of a painting.

Don't become over-ambitious. Steady practice can be most enjoyable and productive.

Don't practise, at least to begin with, on complete paintings. Use small pieces of board prepared with variously textured grounds and try out the techniques described here several times before applying them to actual paintings.

Don't let paint dry in brushes.

Don't dip your brushes into the original jars or bottles containing oil, varnish or turpentine. Pour out a little into old tins or, better still, use dippers, small containers which clip on to the palette.

Tools and equipment

The following list of basic tools and materials has been prepared to help keep your experiments simple yet fully practical. (See the illustrations on pages 4 and 5).

Flat hog-hair, short bristle, sizes 5 and 7
Flat hog-hair, long bristle, sizes 2, 5 and 10
Round hog-hair, long bristle, sizes 3, 5 and 10
Flat sable, long handle, size 3
Fan, hog-hair for later use, size 4
Filbert, hog-hair for drawing and detail, sizes 3 and 5
House painting brush for grounds, size 1½" or 2"
Varnish brush (or large flat hog-hair can be used)
Palette knife, 4" blade
Painting knife, narrow trowel shape
A mahl stick is not really necessary but if required can easily be made by padding the end of a piece of cane or dowel rod of about 1cm or 3/8" diameter and between 45 cm and 60 cm, 18" and 24" long
Hardboard: panels ranging from 15 cm x 20 cm, or 6" x 8", to 45 cm x 60 cm, or 18" x 24"
Turpentine or turpentine substitute
Raw linseed oil
Picture varnish
White acrylic primer for boards

Maintenance and care

To keep brushes, tools and materials in first-class condition it is important to allow sufficient time for cleaning and checking. Tools and materials deteriorate rapidly if neglected. Working with badly maintained equipment is frustrating and misleading as results are inevitably disappointing. Renewal is expensive and wasteful, to say nothing of the bad working habits that can develop in consequence.

After use, clean your brushes with plenty of turpentine substitute and clean rag or tissue, paying particular attention to the base of brisles. Massage bristles in the palm of the hand with soap and warm water, rinse, repeat this soap and water washing until a rich lather develops, then give a final rinse. Gently squeeze out any surplus water and lay brush flat to dry. Brushes can be kept bristle-up in a jar or stored flat in a drawer or tray. Ferrules and handles should be kept clean and polished. Sables should receive very careful handling when washing.

When using acrylic primer for grounds, wash the brush very thoroughly in water immediately after use.

Palette and painting knives should be kept clean with turpentine substitute and polished thoroughly after use. Do not scrape, or use abrasive cleaners. If you have used acrylic paint with a painting knife, wash it with water but dry it immediately as the blade may rust. Keep handles clean and polished.

If you find a particular brush is deteriorating, do not throw it away, keep it for rough work, such as blocking in when you start or for a rough scrubby textured area in a painting. This can help to prolong the life of the other brushes.

Clean the palette with turpentine after each painting session. If you are using a wooden palette rub a little linseed oil into the surface after cleaning.

Let your painting dry thoroughly before varnishing. It is normal to wait several weeks before you varnish; during this period keep the painting in a vertical position so that it does not attract dust, and protect it from direct sunlight.

I wish you success with your painting. I trust that this book will have helped and encouraged you to improve your brushwork and increased your enjoyment of an activity which well repays constant practice.

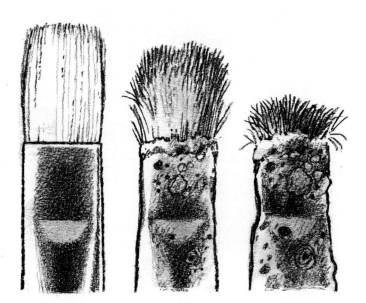

ACKNOWLEDGEMENTS

First published in Great Britain in 1982
Search Press Limited, Wellwood, North Farm Road,
Tunbridge Wells, Kent TN2 3DR

Reprinted 1993

Text, drawings and paintings by Clifford Bayly

Text, illustrations, arrangement and typography
copyright © Search Press Limited 1982

Distributors to the art trade:

UK

Winsor & Newton,
Whitefriars Avenue, Wealdstone,
Harrow, Middlesex HA3 5RH

USA

ColArt Americas Inc.,
11 Constitution Avenue, P.O. Box 1396, Piscataway, NJ 08855–1396

Arthur Schwartz & Co.,
234 Meads Mountain Road, Woodstock, NY 12498

Canada

Anthes Universal Limited,
341 Heart Lake Road South, Brampton, Ontario L6W 3K8

Australia

Max A. Harrell,
P.O. Box 92, Burnley, Victoria 3121

Jasco Pty Limited,
937–941 Victoria Road, West Ryde, N.S.W. 2114

New Zealand

Caldwell Wholesale Limited,
Wellington and Auckland

South Africa

Ashley & Radmore (Pty) Limited,
P.O. Box 2794, Johannesburg 2000

Trade Winds Press (Pty) Limited,
P.O. Box 20194, Durban North 4016

ISBN 0 85532 444 9

Printed in Spain by Elkar, S. Coop. - 48012 Bilbao